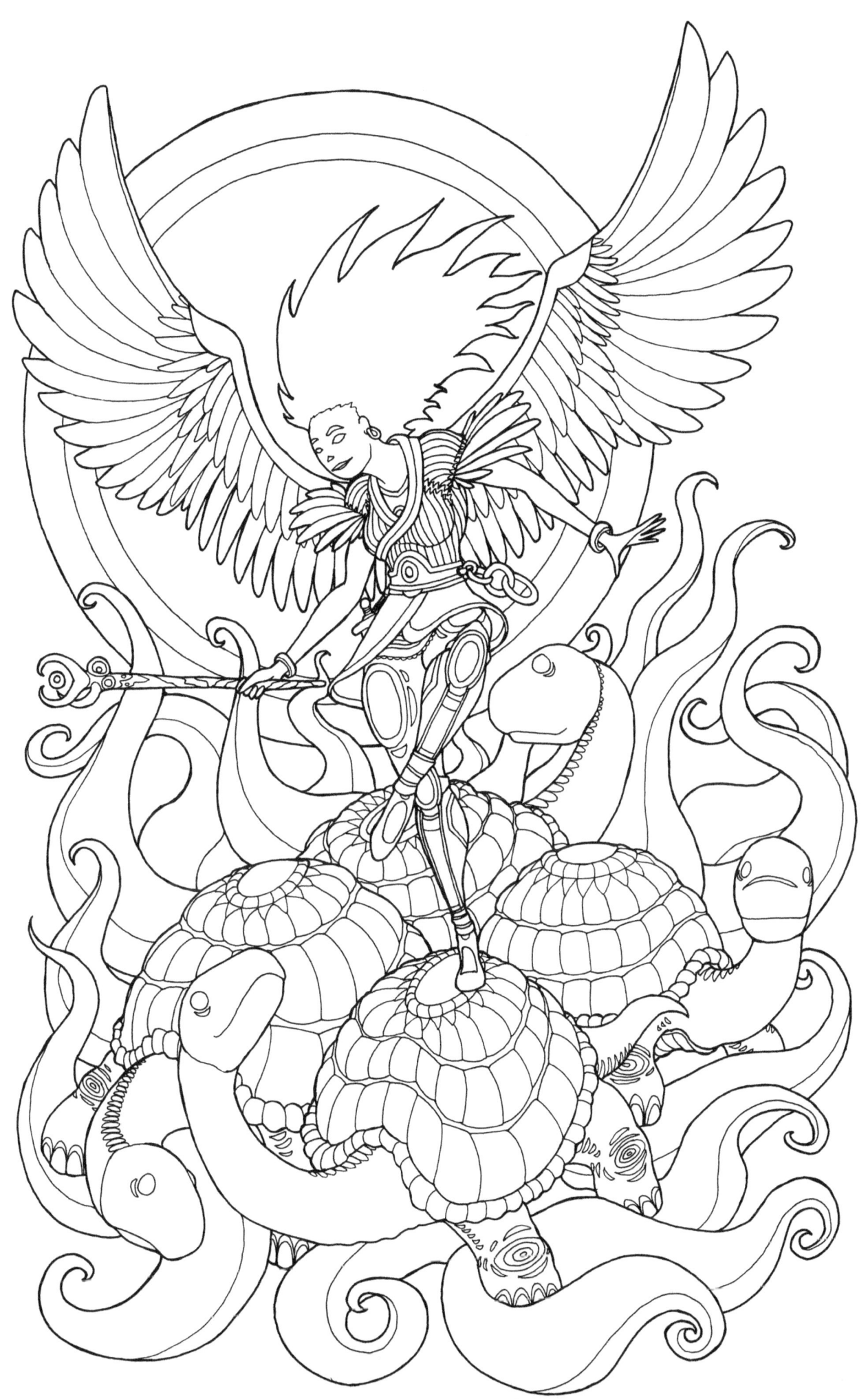

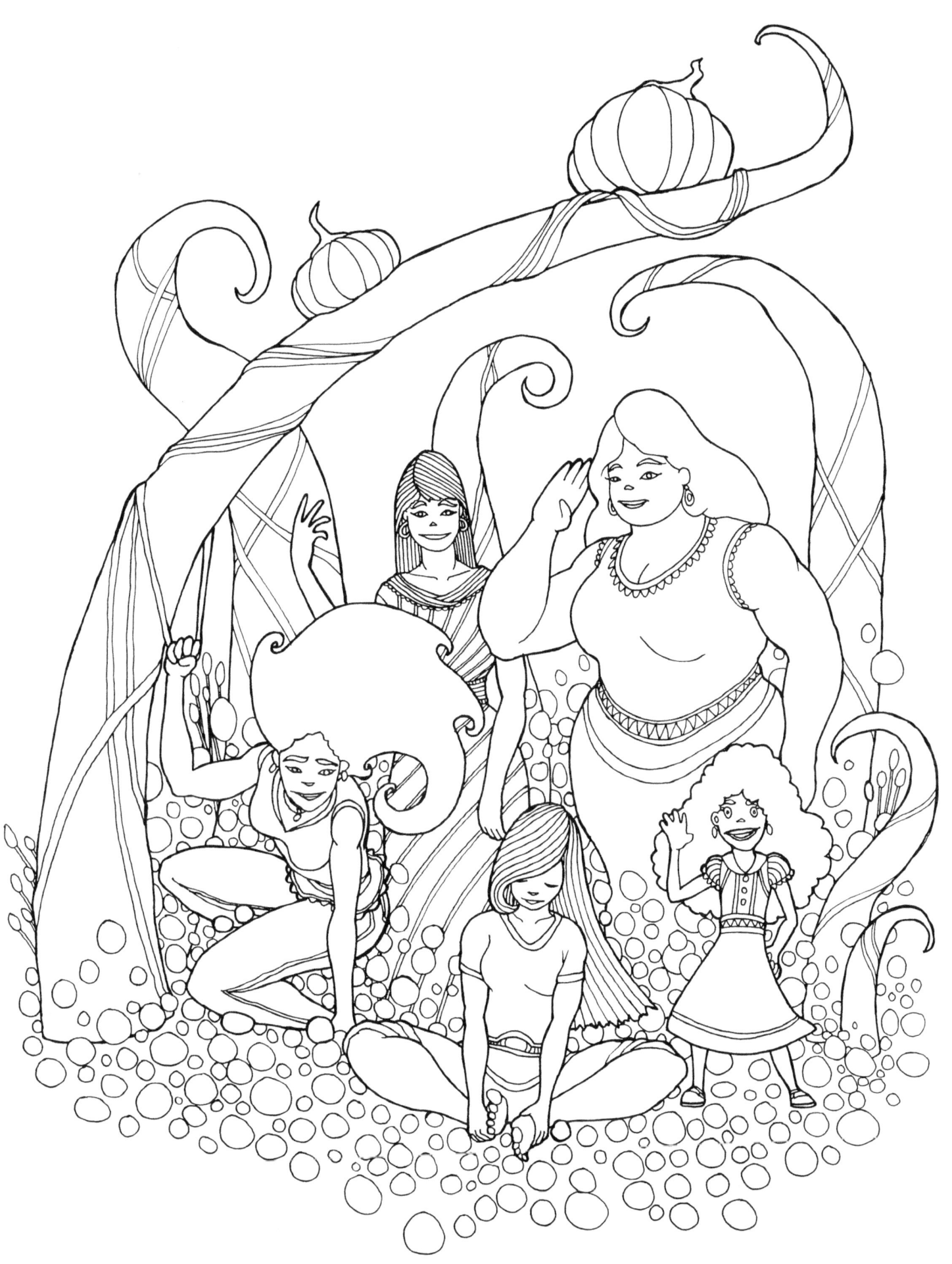

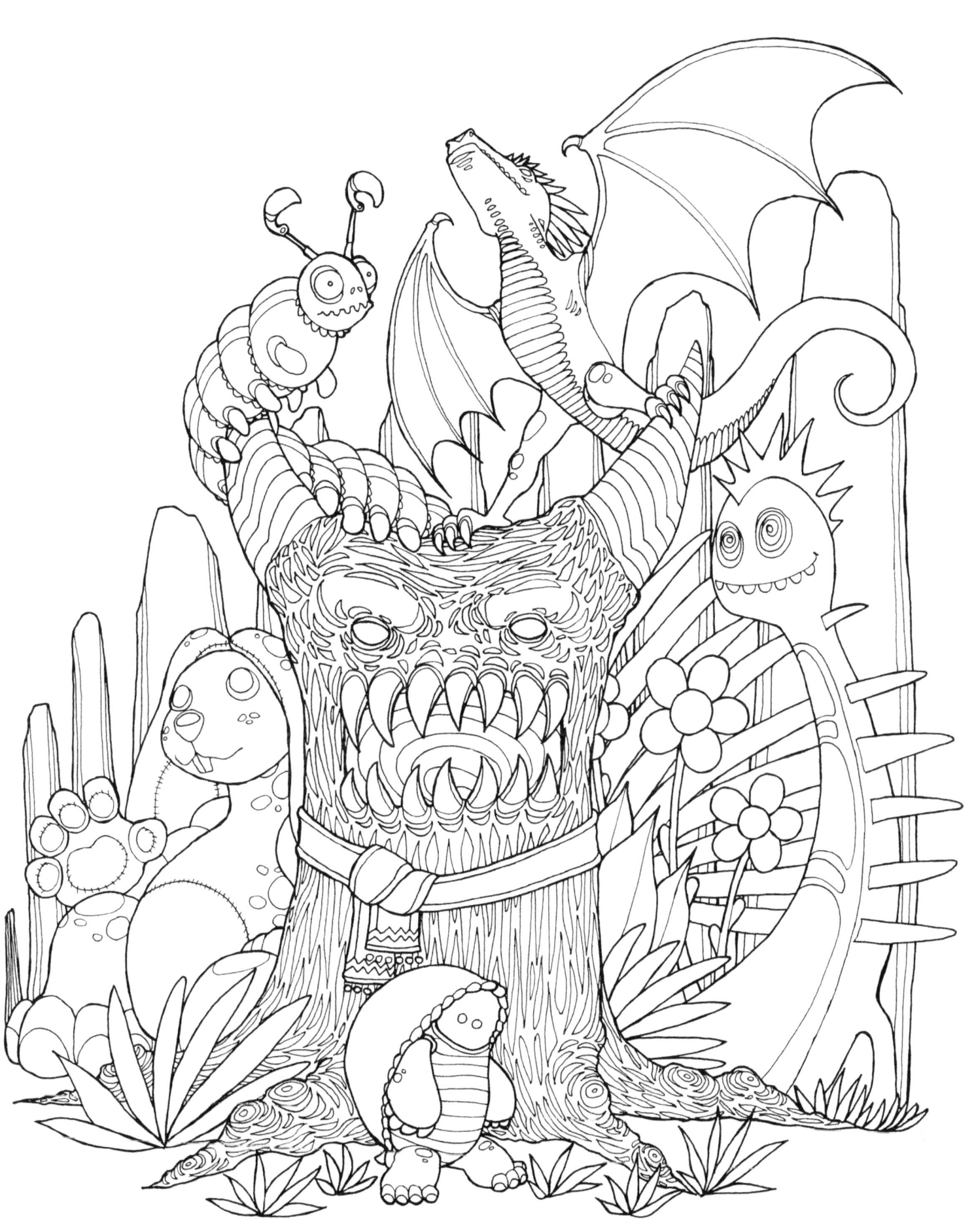

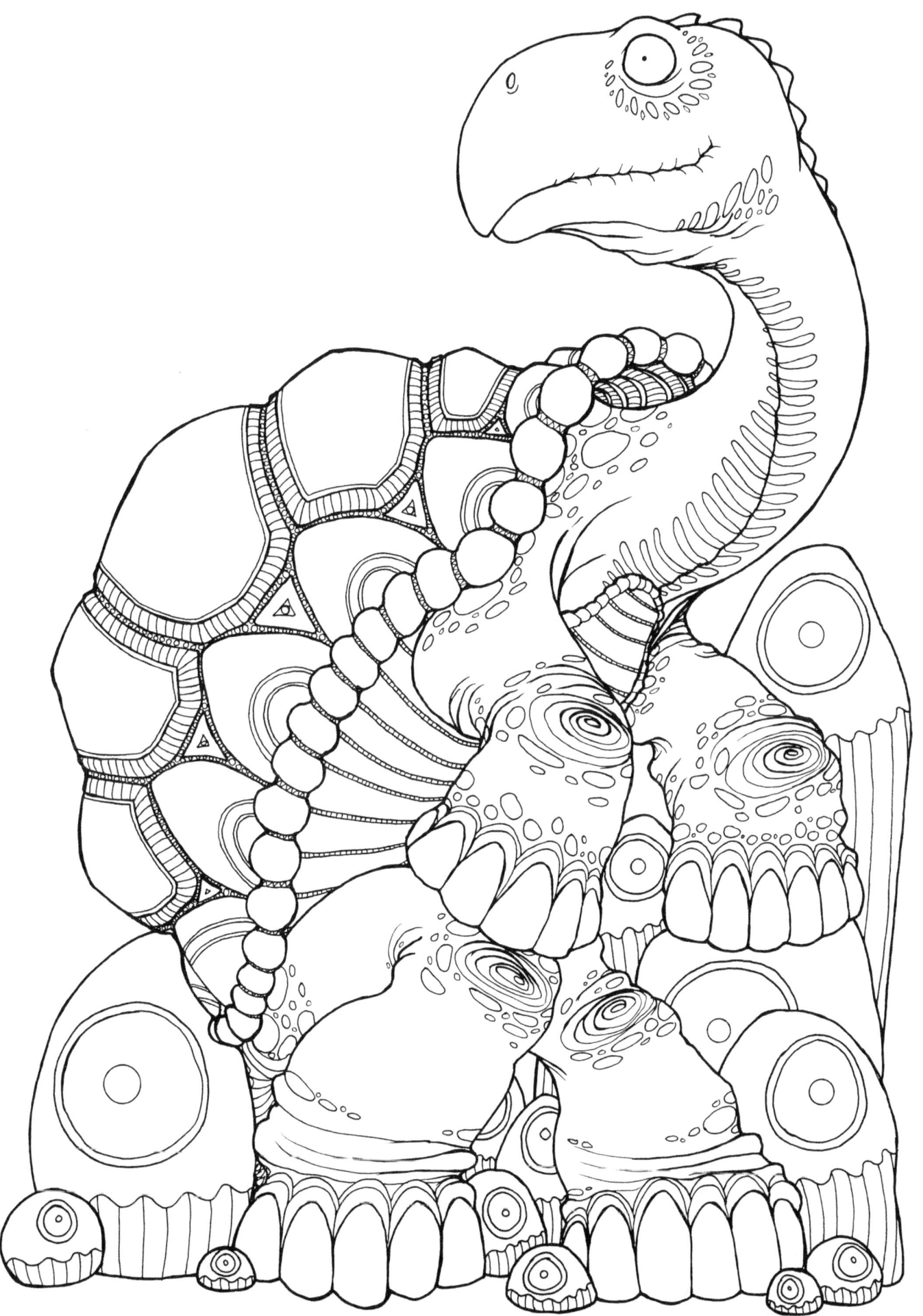

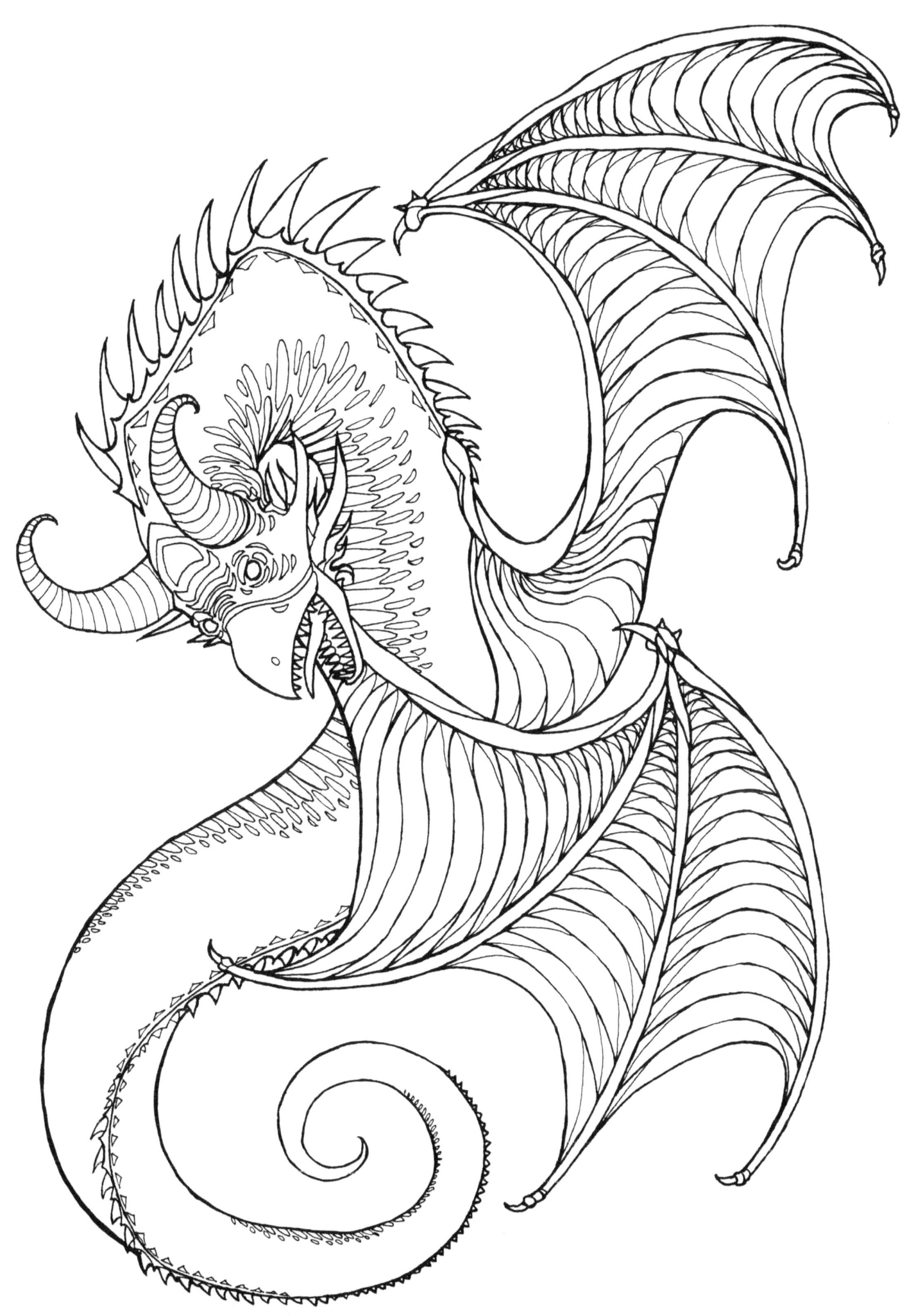

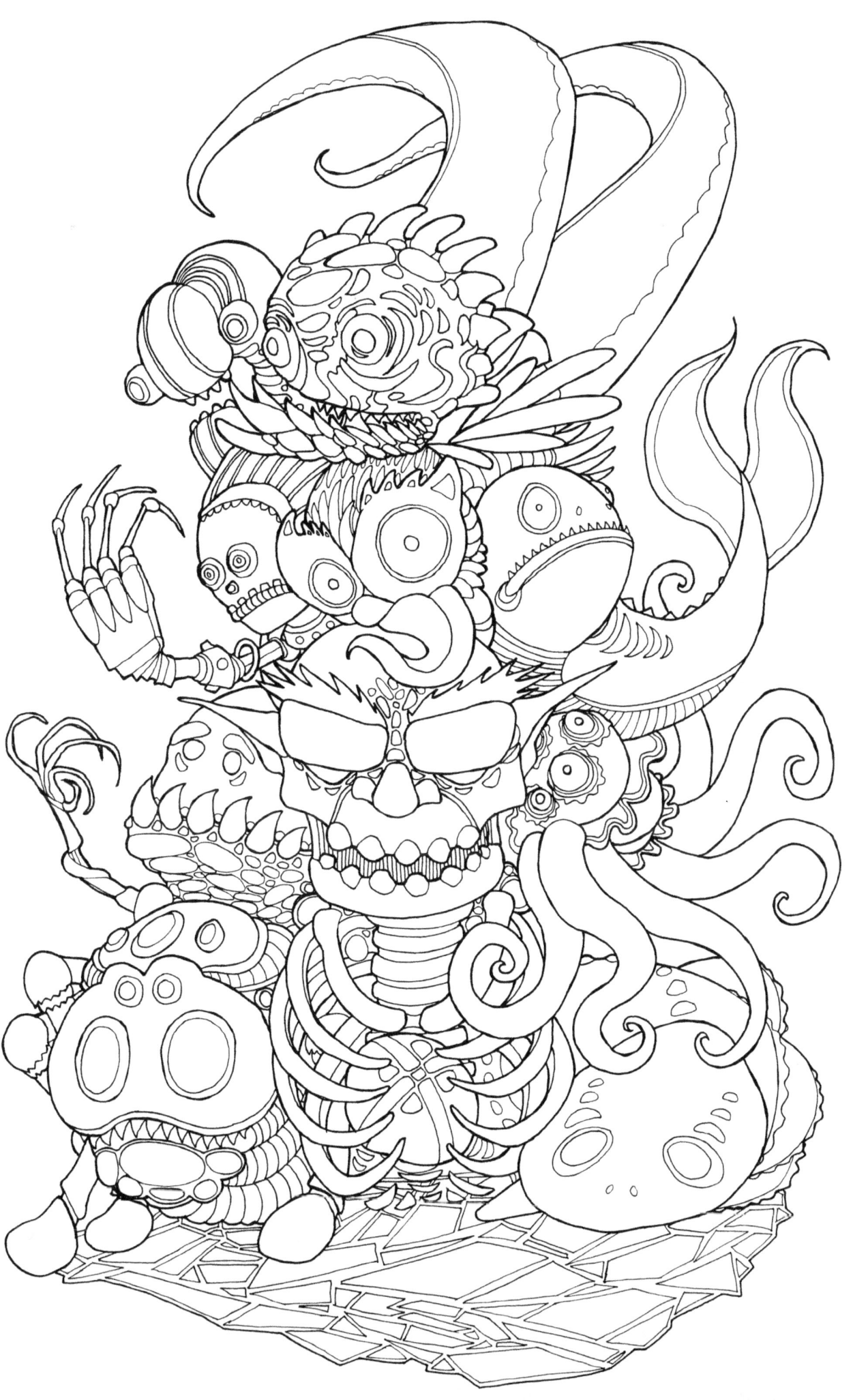

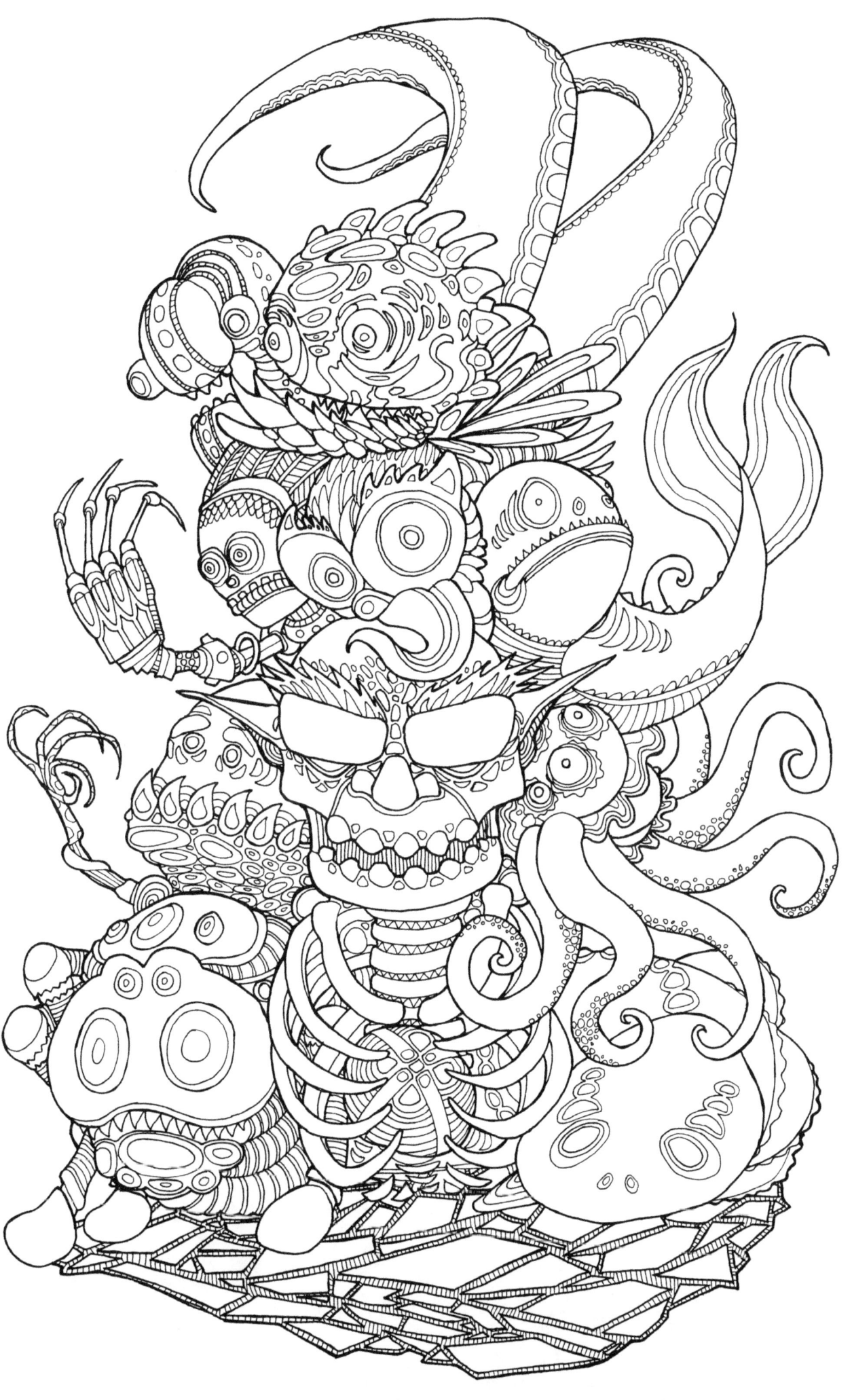

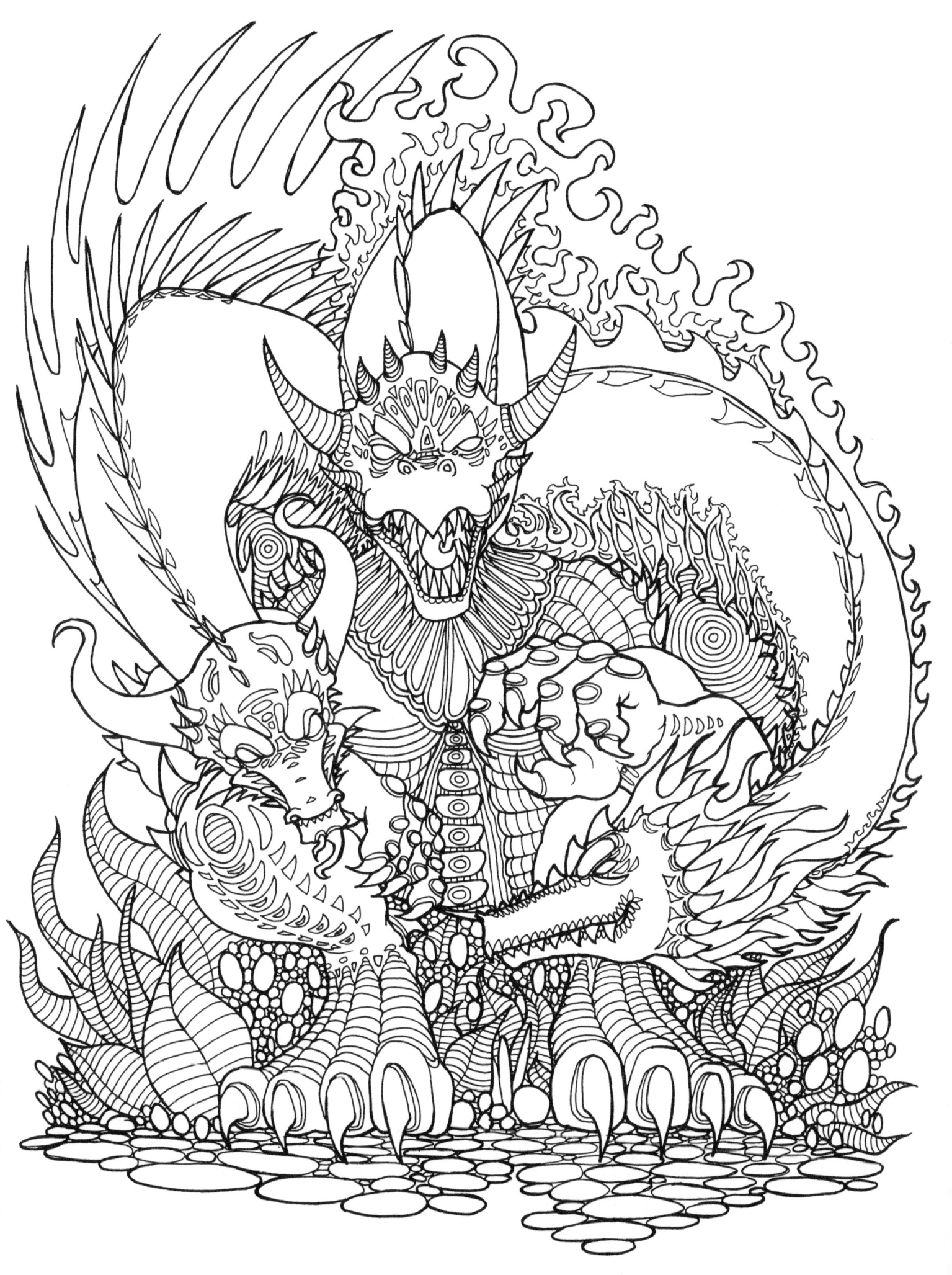

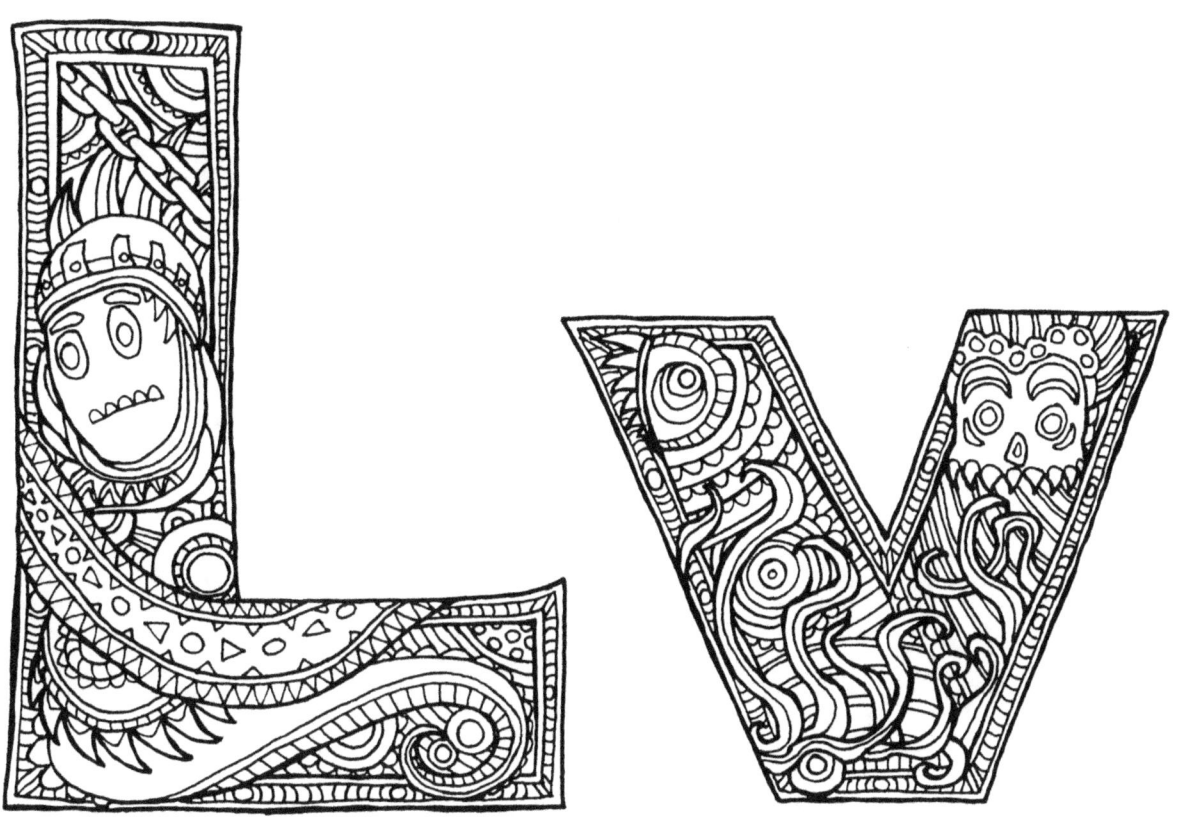

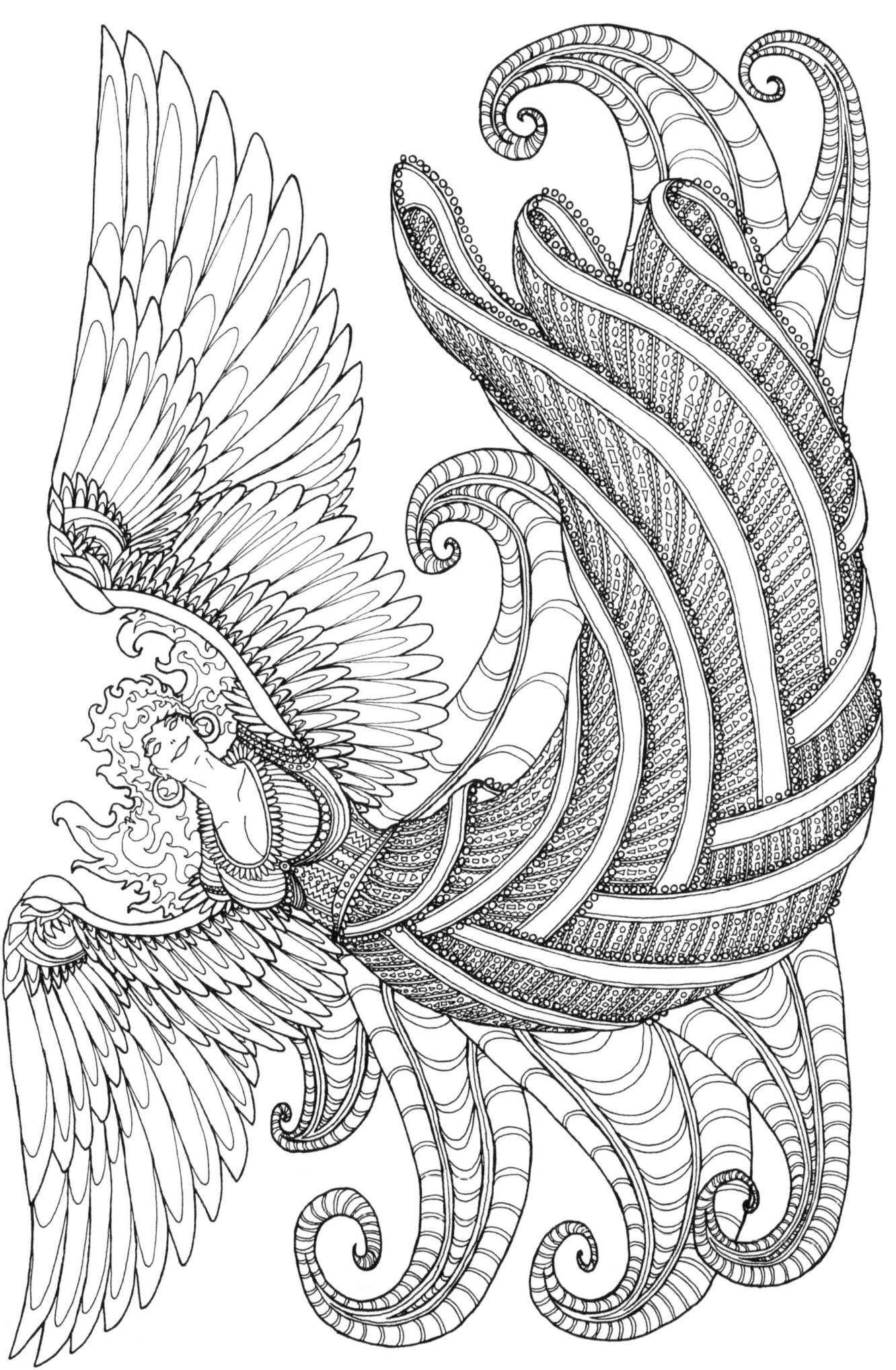

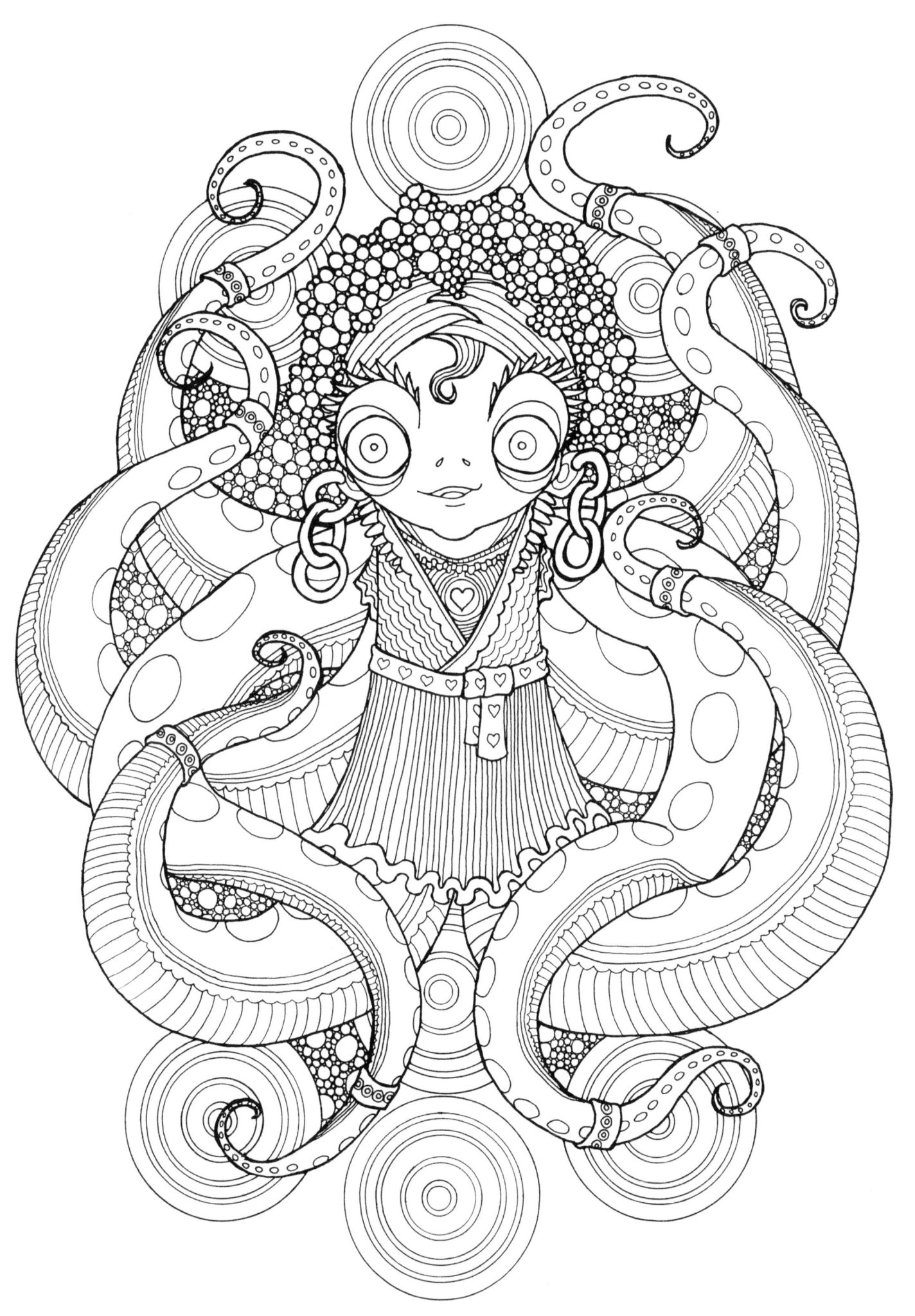

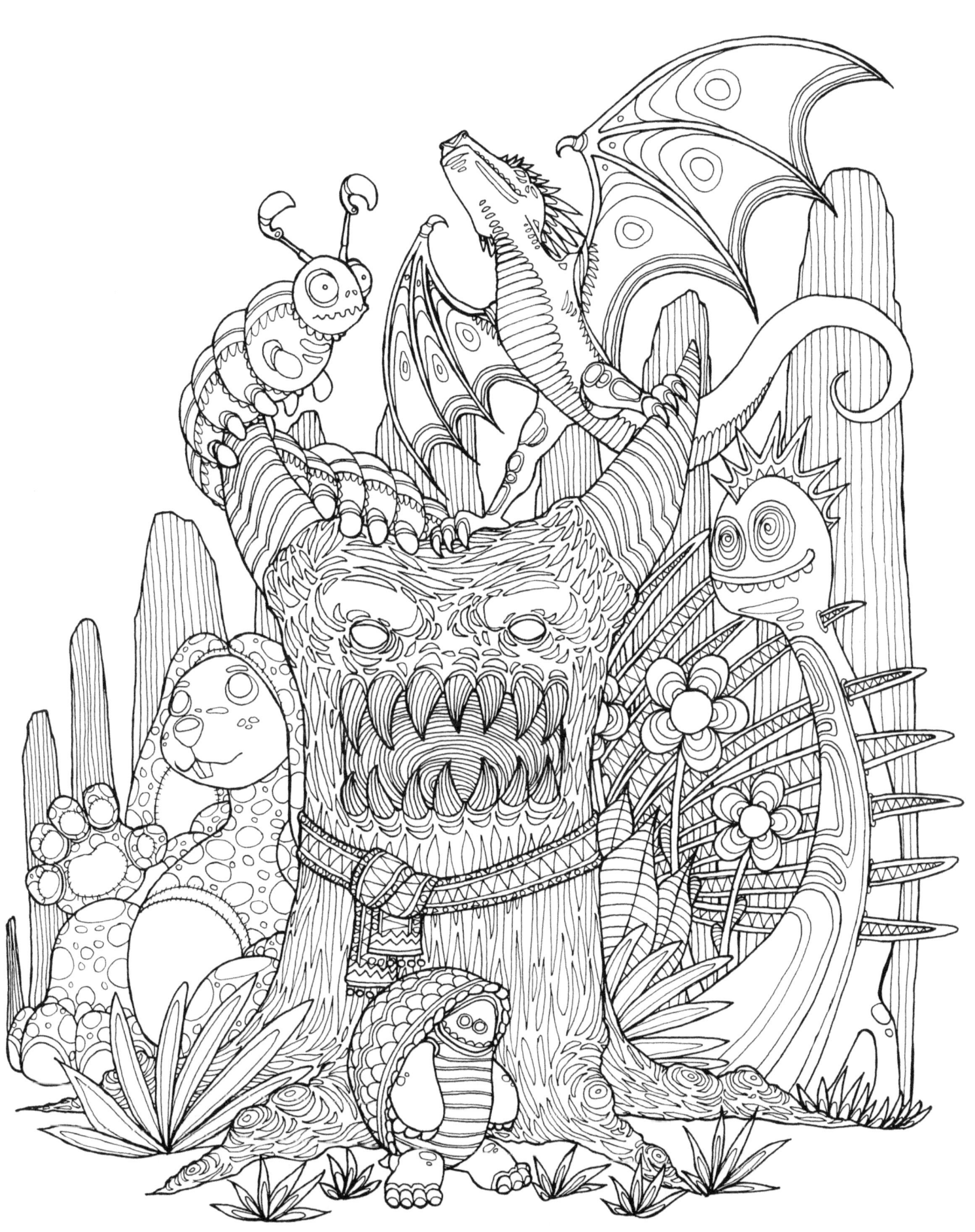

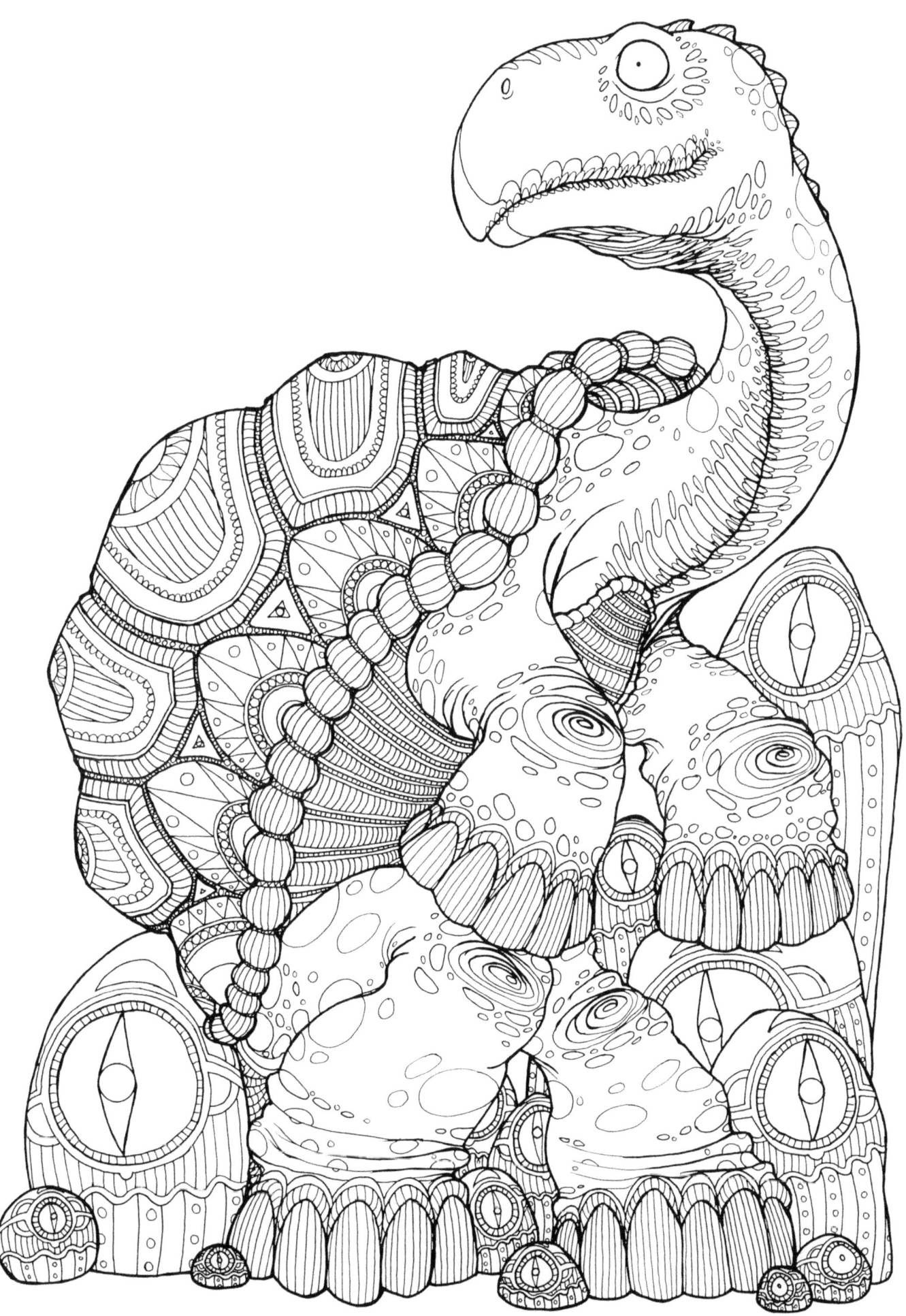

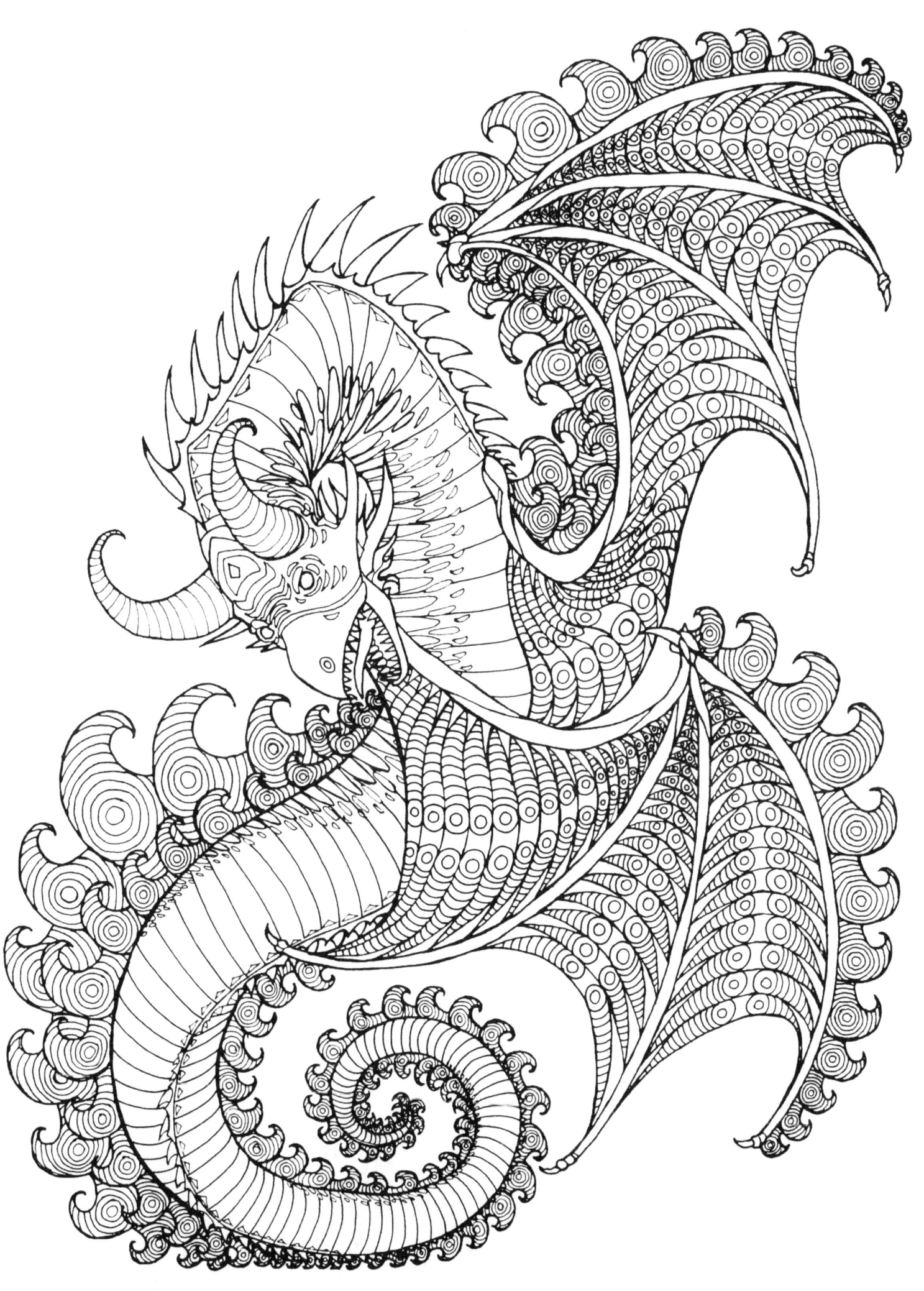

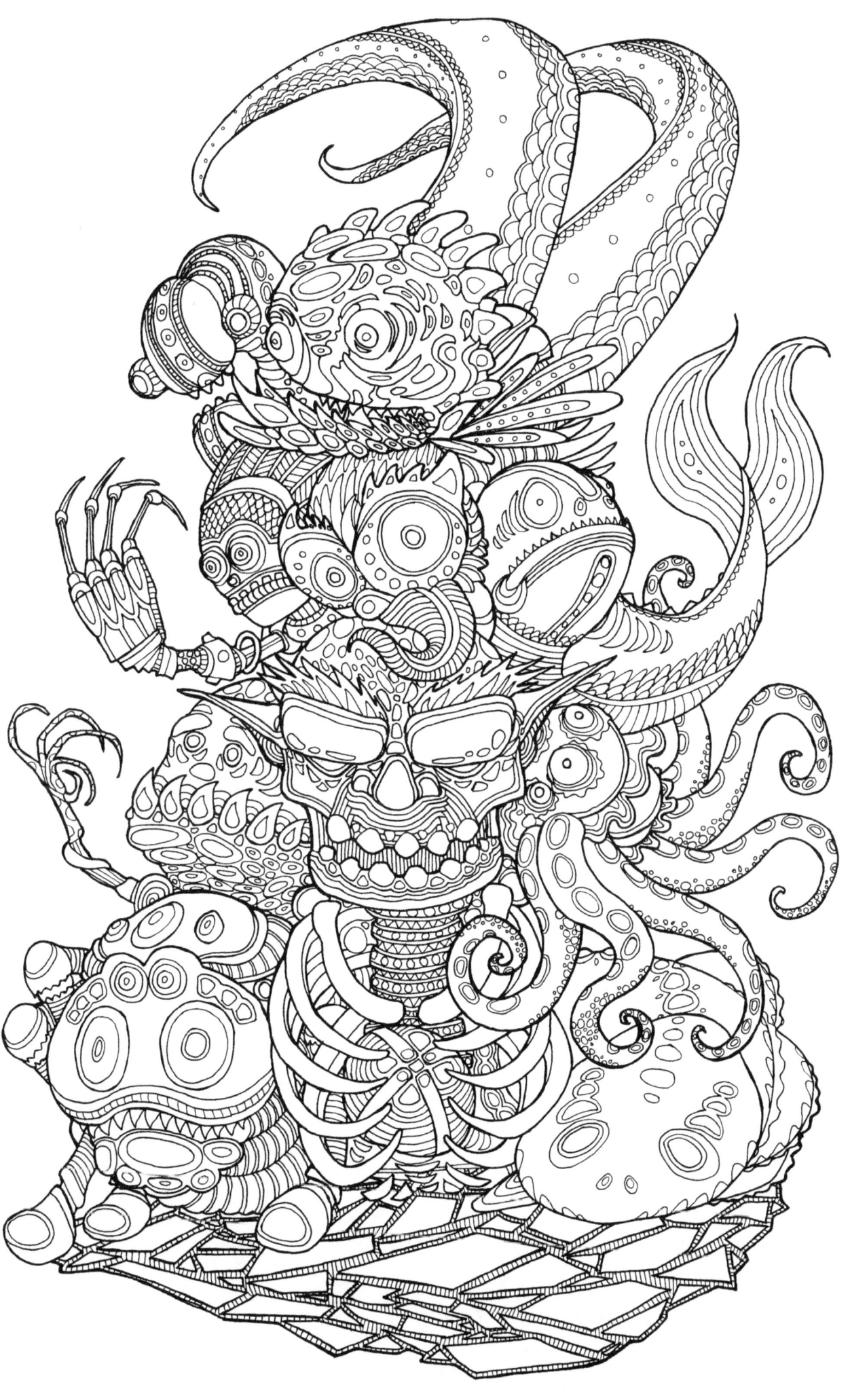

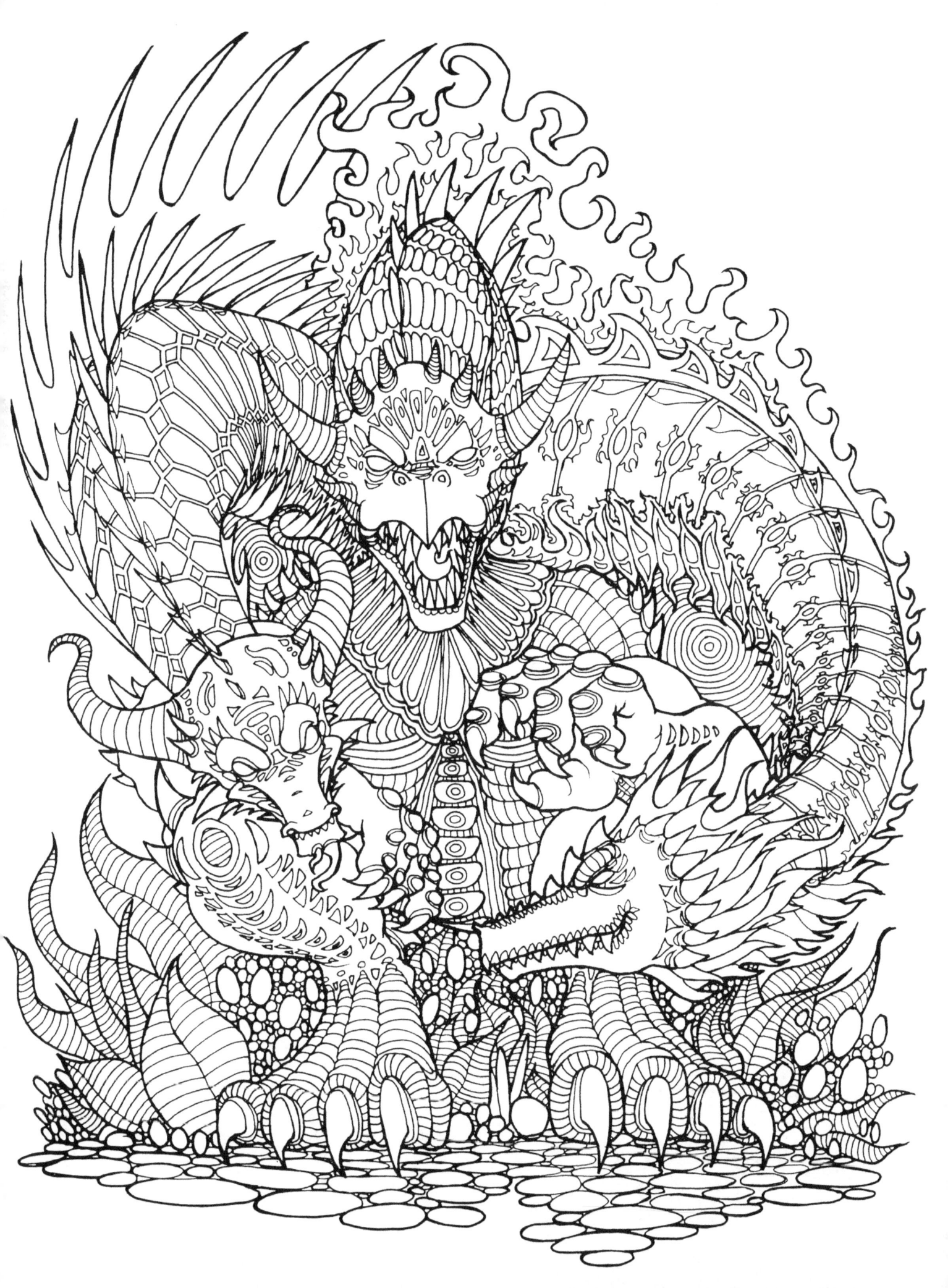

About the Author

Tyler Warren is an artist and writer currently serving in the United States Air Force. Tyler first joined the US military in 2000 by enlisting in the United States Marine Corps. He has a BA in Economics and an MA of Innovative Leadership.

Tyler was the speechwriter to the Commander of Air Force Materiel Command, out of Wright-Patterson AFB, Ohio. There he crafted strategic messaging for the 4-star Commander, Vice Commander, and Executive Director. He was honored to have written speeches for the Air Force's first female 4-star, General Janet Wolfenbarger (now retired).

As a freelance illustrator, Tyler has produced projects for a variety of industries and his artwork can be seen featured in books, on dairy products, on college sports websites, as logos, and in video game making software (RPGMaker).

Tyler and his bride Andrea have eight children and reside in Alabama.

Dedicated to Andrea, my bride and my best friend.